LETTER TO DR FRENKEL

Treasures of a community laid to waste

By Ebrahim el Hadidy

CONTENTS

Preface

1. The coffee set

2. The Hanukkah lamp

3. The Kiddush train

4. The painting

5. The diary

Epilogue

©Ebrahim el Hadidy, 2013

Letter to Dr Frenkel. Treasures of a community laid to waste

Facilitated by Nederlands Auteurs Bureau, Blaricum, the Netherlands

Final edit of the Dutch: Matty Zwart-van Dijk
Translation into English: Anita Graafland, mother of my first-born Adam El Hadidy
Final edit of the English: Tom Scott

All Rights Reserved
No part of book or any of its contents may be reproduced, copied, modified or adapted, without the prior written consent of the author or publisher.

Preface

Dear Reader, please allow me to introduce myself. My name is Ebrahim el Hadidy and I am a Dutchman of Egyptian descent. I was in my twenties when I moved to the Netherlands in 1988 and have been employed as a social worker since 1990. One memory stands out for me to this day: after I'd applied for my first job as a social worker in the Netherlands, I received a phone call from the director who said: "Congratulations Ebrahim, *we gaan samen in zee*," which means something like 'welcome on board' in this particular context but literally translates as 'we'll go into the sea together'. I stood and thought for a minute and then said: "I'm very sorry, sir, but I can't swim." I heard him erupt into laughter at the other end of the phone and had no idea what that was all about. That's how hard Dutch was for me – but I was desperate to learn and get to know this complex language a lot better.

I have a lot of interests: I paint, I like doing up homes and I'm fascinated by antiques. The world of silver has had my interest since 2003, and when I started to bone up on it I found a completely new world opening up for me. Over the past decade or so, then, I've been collecting unusual silver antiques, never caring or knowing where they came from – Jewish, Christian, Muslim or whatever. My interest wasn't with any particular

faith or background – I'd just fall in love with the beauty of a piece, and I bought many of them that struck me as special or particularly fine.

To be brutally honest, I was quite mercenary at first: I was looking to buy antique silver to sell it on and make some money on the side. That's not how it turned out, though: I ended up buying silver objects that I thought particularly beautiful and just kept them. I'd spend hours and hours researching where a piece came from, what year it dated back to and what its particular history was. The world of silver antiques turned into a passion alongside my day job and has brought me a lot of joy. And it's the story of my collection that I'd like to share with you.

In 2010, my GP referred me to an orthopaedic surgeon because my knee was giving me a lot of trouble. While Dr Frenkel and I were looking at the X-rays and discussing the surgical procedure, we got to talking about the Second World War and my collection of Jewish pieces. I told him that I'd become completely immersed in silver antiques, that I had planned on becoming a trader but had turned into a collector instead. He found this amusing: "Making money hasn't gone so well then," he observed. No, it hadn't: I felt my pieces were too beautiful and valuable to sell. In fact – or so I told him – I was planning to write a book about it, and I'd even come up with a title 'Treasures of a community laid to waste'.

He gave me a somewhat surprised look and said: "I'd like to read it." Here I was, an Egyptian Muslim, talking about the

Second World War, Jewish history and Jewish heritage. When I apologised for perhaps touching on painful issues, he reassured me: "That's no problem, I find it quite fascinating to see how this engages you."

I said: "My plan is to describe five objects in my collection in five short stories. It doesn't really matter what order you read them in, you could read the last story first or the other way around." I also decided then and there to change the title of my book into *Letter to Dr Frenkel*. "I'm honoured," he replied, "but that's not necessary."

I told him: "Every piece I liked turned out to be part of myself, a journey to who I am and what I've become through all these objects – the interaction between me and every piece that touched me. And when started to investigate their background, it was myself that I found."

Dr Frenkel gave me the email address I could send my story to – he looked forward to reading it, he said. I felt we'd somehow become friends but I could tell from his face that he thought I was a bit... well, unusual.

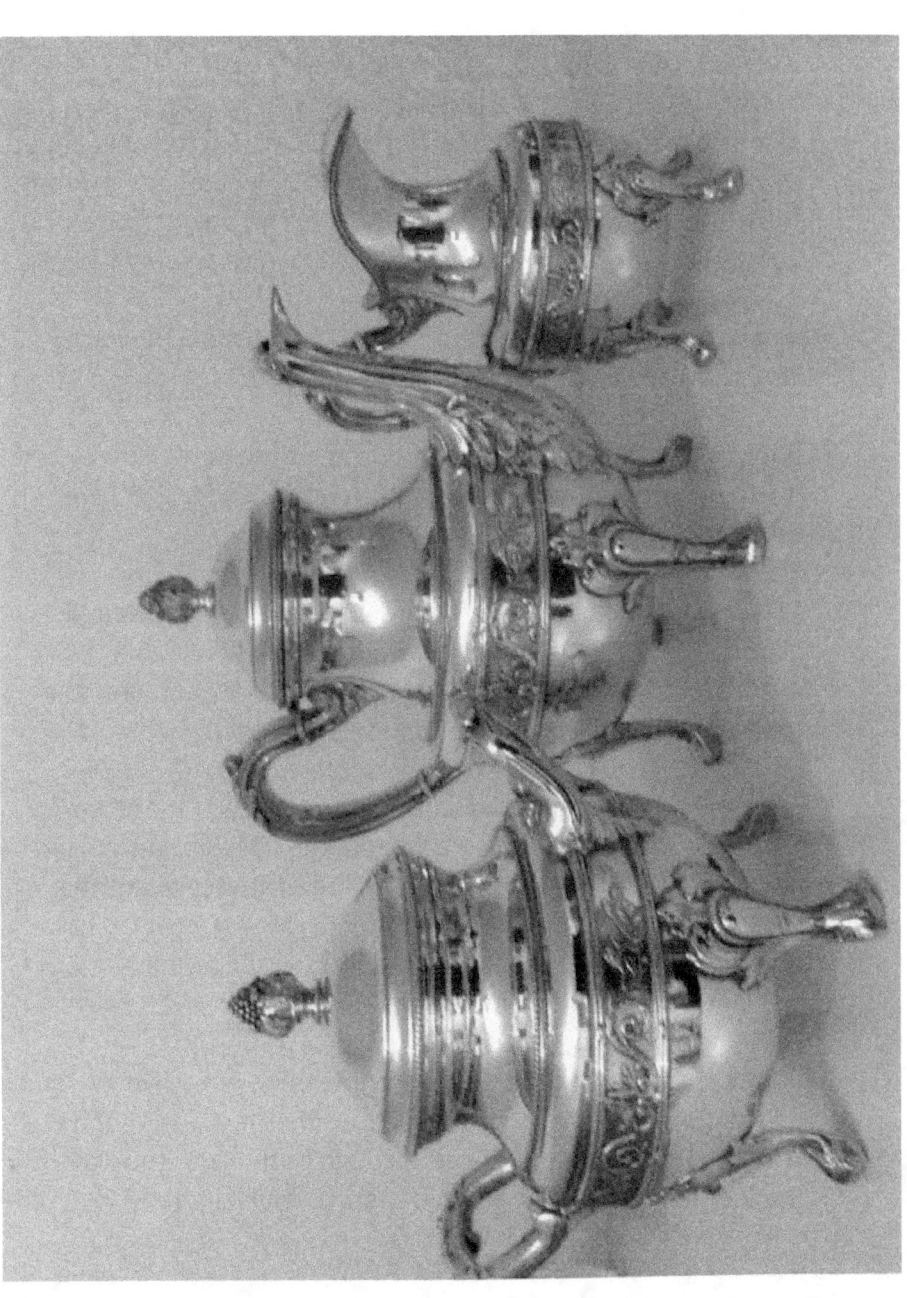

1. The coffee set

The first piece from my collection that I'd like to tell you about, Dr Frenkel, is a richly decorated French silver coffee set dating from 1840. I didn't just think it was very, very beautiful; it comes with an engraving that is special to me and my family:

In grateful memory of our mother's courageous and loving care during the war, May 1940 to May 1945.

The words in the engraving got to me – they reminded me of my own mother. I hail from a culture in which mothers are honoured and have a special role to play.

This piece also got me even more interested in the Second World War, and I spent many a night online researching everything I could find about it. I decided to try and find this mother and learn her story.

I've read lots of books and stories about the war that shook Europe – and perhaps even more online. The lines on the bottom of the coffee pot reminded me of stories about the German occupation of the Netherlands. My idea was to write down this courageous mother's story once I'd found her, but I was in for a sad and painful journey.

I remember reading that Queen Wilhelmina of the Netherlands had been one of the most courageous mothers during the war – and that she'd actually lived through both wars. The Dutch think of her as *Moeder des Vaderlands*, which literally

translates as the 'Mother of the Fatherland'.

Address to the nation by Queen Wilhelmina on 10 May 1940.

My People,

After all these months during which our country has scrupulously observed a strict neutrality, and while its only intention was to maintain this attitude firmly and consistently, a surprise attack without the slightest warning was launched on our territory by the German armed forces last night. This in spite of a solemn guarantee that our neutrality would be respected as long as we maintained it ourselves.

I hereby raise a fierce protest against this unprecedented violation of good faith and outrage upon all that is proper between civilized states. I and my government will continue to do our duty.

You will do yours, everywhere and in all circumstances, each in the place he occupies, with the utmost vigilance and the inner peace and devotion which a clear conscience affords.

Call me naive, Dr Frenkel, but I thought the coffee set had belonged to Queen Wilhelmina and decided to offer it to her granddaughter, Queen Beatrix. I'd heard that her father, Prince Bernhard, had been known to sell off silver from time to time, and a colleague at the Haarlem smithy told me that the royal family would regularly buy back pieces that had previously

belonged to the family.

"But why the Queen?" my Russian wife asked. I told her that the Queen's grandmother Wilhelmina had been a courageous mother during the war. My family thought I'd gone off my rocker and just laughed in my face. "Sell to Her Majesty? Ha, ha – you're nuts, Dad," my son Adam said. They thought I was a simple man with simple ideas. To be totally fair, I'd been kidding around a bit but now felt obliged to take this further. I wasn't interested so much in selling, I wanted to hear this story of the courageous mother. She might well have been the Queen.

And so I cajoled a co-worker of mine to help me write a letter to the Queen. She was very supportive throughout, but she too clearly thought I was being pig-headed. I suppose I just wanted to prove to myself and my family that anything was possible in this country, even communicating with Her Majesty herself.

I received a reply from the Royal Family two weeks later – and was delighted to receive a reply at all. Here it is:

Thank you for the offer to buy a French 19th century coffee set with engraving on the bottom. We regret to say that we see no immediate connection with the Royal Family. Although it is a fine piece with a beautiful inscription, it does not meet the requirements of our purchasing policy and the collection we manage. This does not alter the fact that we appreciate you taking the trouble to contact us.

Mrs L. V., curator of the royal art collection, may have seen nothing to tie the coffee set to the Royal Family, but I was delighted to receive a letter on behalf of the Queen.

OK, so the coffee set hadn't been Queen Wilhelmina's. But who had it belonged to, then? I continued my search.

Old hands at the silver trade said: "Son, just scratch out the inscription and sell it off. It won't do you any good to know who used to own it." Turns out I'm no trader, as I really struggled with the issue: to sell or to keep looking for this courageous mother and her story.

I felt morally obliged to get to the bottom of the story, to do justice to a mother who had been full of courage at a time of war. I couldn't just ignore that, I wanted to find out who this mother was and what she had done in the war. I wanted to know who had given the coffee set to whom. I was in for a painful search, as I found out more and more about the war.

I travelled up and down my adopted country looking for the courageous mother of the coffee set, and I heard lots and lots of stories about many courageous mothers. I would need a thousand books to recount all the stories I heard: every Dutch household has a story of a brave mother or grandmother during the war.

I was horrified to find out about the large numbers of Dutch Jews prepared to set up Jewish councils, knowing this would facilitate efficient identification and deportation. I spoke to

Dutch people who believed the Resistance never existed and that the country merely served as a holiday destination for the Germans. Others, by contrast, felt guilty for failing their fellow man and turning a blind eye. Some told me there had been lots of people who had been all too eager to betray their countrymen to the Germans, particularly in the bigger cities – even police officers, who were keen to get the two-and-a-half guilders they could make per Jew.

Dr Frenkel, I may have received a solid university education in Egypt, but I knew next to nothing about the Second World War. The only thing I knew was that Nazi Germany had sought to become a superpower and occupied a bunch of countries to make that happen. Somehow, I'd always believed this was a fight between two or more countries; I had no idea this war was also intended to eliminate specific sections of the population.

I learned that the Germans had set up lots of concentration camps for specific groups of people and started deporting them. I also found at that quite a few of the Dutch had unsuccessfully protested these deportations, and that many had no idea what exactly was happening to the people being so deported.

Men aged between 18 and 45 were given no choice: they had to go and work in Germany. With many of them gone into hiding, there were hardly any men left to fight the Germans. In addition to Jewish children and men under 45, refugees from Germany and Eastern Europe also went underground.

What I did find out was that hundreds of thousands of women and mothers had put up a formidable fight against the German occupiers, brandishing their sense of motherhood and community as their weapons and acting from a religious conviction that they should help and care for their fellow men. Hundreds of thousands of women and mothers were actively involved in providing shelter to Jewish people gone into hiding and men who didn't want to go and work in Germany, in looking after Jewish children and bringing food and other necessities to the many who relied on them.

All across the country, women and mothers stuck their necks out for Jewish children and people in hiding – they were there for them, whatever the risks or repercussions. One woman told me that many Jewish children were the only ones to escape the gas chambers because of them.

A large stream of people went into hiding in Friesland, which wasn't just taking in Jews and men under 45 but a good many refugees from outside the Netherlands as well. The resistance movement there was well organised and the province still had some food to share. Food was rationed and rations were increasingly reduced, though there were no ration cards for Jews and other people in hiding, of course. People in Friesland, I discovered, are rightly proud of themselves and their grandparents, and the stories I heard showed that they truly were heroes. I've resisted the temptation to tell their stories here, as I would never get to the end of my own.

I remember one time when I was driven to somewhere near the village of Aalten in the province of Gelderland, near the German border. My companion stopped at a farm and told me his mother used to live there and that the farm had harboured many Jewish children and Jewish German refugees at the time. His mother later told me she'd seen children who had been brutally separated from their parents and who lived in fear of death every day. She understood how hard it was for children to survive without the protection of their own parents. Around 2,500 Jewish children were kept safe and hidden in Aalten during the war, alongside many other refugees from Germany and neighbouring countries.

As I've said, the sheer strength, courage and force of will of these women had its origins in deep-rooted faith and a strong sense of community. The resistance was everywhere and stories of brave mothers abounded. The most well-known of them were Henriëtte Pimentel, Miep Gies, and Corrie ten Boom, but many, many unknown women saved Jewish children by hiding them. Mothers all across the country.

So here I was, looking for that one courageous mother and owner of the silver coffee set, and I found an army of women and mothers that had stood up against Nazi Germany, that had stuck out their necks to save other people's lives and fight for the honour and freedom of the Dutch. These mothers, I feel, were the true soldiers of Orange.

For me, this silver coffee has become a symbol of gratitude of everyone that went into hiding for all the women and mothers

across the country. A thank you to those mothers who had the guts to save the lives of their fellow human beings, who were blind to colour, religion and race.

In grateful memory of our mother's courageous and loving care during the war, May 1940 to May 1945.

Dr Frenkel, I've kept up the search for that one mother, but have so far been unable to find her. I would have loved to have met her and talked to her, but I doubt I ever will. She's probably dead by now and very likely her silver was put up for sale after her death.

The coffee set is truly beautiful and valuable to me, I think, because I identify with these children in hiding. Children who more than anything must have missed the love and warmth of their parents, particularly their mothers, and who simply longed to go home to the way things had been before. I saw my mother in this mother. I went looking for her across the country, hoping I would meet her one day. And while I searched, I often thought of my own mother. How she would open the door for me and call my father: "Abdou, Ebrahim's home!" How they would both hug me and be so happy to see me.

My mother had brought ten children into this world. During one war, she saw no less than six of them serve in the army, simply because military service is compulsory in Egypt. I saw in my mother's eyes how much she feared not seeing her children again; how she hoped that everything would turn out OK. My

mother thought that war was the stupidest thing that people had ever come up with.

I haven't been to visit my family since my mother died; I wanted to hold on to the feeling that brave mothers never die, that they live forever. I can feel the pain of those children in hiding, separate from their parents; all of them longing to go home after the war, to their parents. Unfortunately, their parents were often gone for ever.

It wasn't until I went on my search that I fully realised that my mother is dead, and how much that hurts. It was my own mother I recognised in the brave mother of the inscription, which is engraved in my own heart.

My search for this one mother opened my eyes to the recognition due to all mothers in this country, and I'd like to think of the coffee set as a sign of appreciation of all courageous mothers and women on earth.

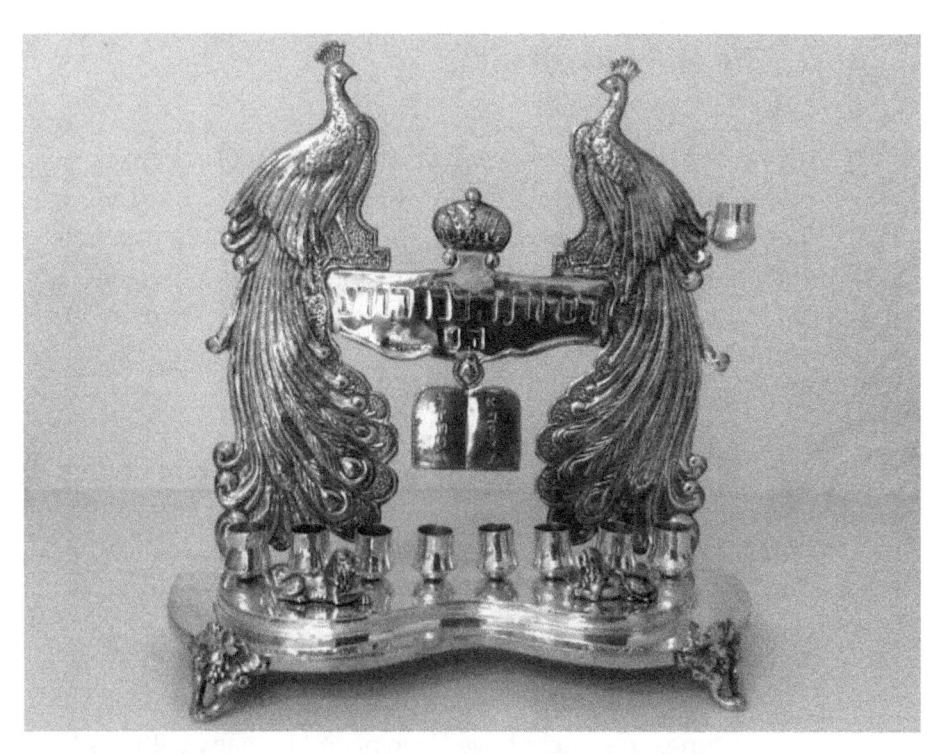

2. The Hanukkah lamp

My next story concerns a special piece in my collection, a Hanukkah lamp from Vilnius in Lithuania, dating from 1889 judging by its hallmark. I remember seeing it for the first time and admiring its design: it's absolutely stunning. When I bought it, I thought I was dealing with an Islamic candelabrum because of the two peacocks, peacocks being a recurrent motif in Islamic art.

A few months after the purchase I started delving into the piece and found it was a Hanukkah lamp. I paid a visit to the Jewish Historical Museum here in Amsterdam to look for similar pieces, but failed to find any quite like mine. It struck me that old Hanukkah lamps often had two lions bearing a crown, but this one featured two peacocks doing this.

For centuries, peacocks have been prized in many cultures as symbols of wealth and beauty, their royal elegance capturing the finer things in life. In fact, in many religions they feature as a symbol of immortality, beauty, dignity and pride.

The Torah, I discovered, mentions the peacock as a symbol of wealth and prosperity, reflecting also the faith of the people. Across the centuries, the peacock has served as a symbolic object of contemplation, with many cultures clearly seeing the hand of the Divine Artist in the complex patterns of its plumage, whose level of detail bears testimony to His

unparalleled handiwork. The eye patterns in the plumage also serve as symbols of God's all-seeing eye. Just like eagles, peacocks enjoy even more stunning plumage after moulting, and Muslim cultures believe that peacock feathers keep the temptations of the world at bay. As the many pieces of art featuring peacocks show, this is an important creature in many cultures and religions.

Not knowing the first thing about Judaism, I really wanted to know what a Hanukkah lamp was. I could see with my own eyes that I was dealing with a candelabrum, but when was it used and what, if any, was its religious meaning?

The Hebrew word Hanukkah means dedication or consecration. Hanukkah is the Festival of Lights commemorating the rededication of the Holy Temple in Jerusalem. It's the story of religious and national freedom, of saving one's own identity, of the few that rose up against the many – the feast of lights and miracles.

Hanukkah does not get a mention in the Torah, as it celebrates an historical event after the Torah was written and before the Bible took shape.

In 164-167 BC, a small group of Jewish rebels made for the wilderness of Judea, led by Mattathias and later by his son Judah Maccabee, revolting against their Greek overlords. Things had come to such a point that the Greeks had desecrated the Holy Temple of Jerusalem by slaughtering swines on its altars, an animal the Jews consider unclean. And

so the rebels fought a risky war against their oppressors and were able to retake the Jerusalem Temple three years later (the First Temple had been built during the reign of Solomon and later rebuilt as the Second Temple by the Jews returning from exile in Babylon). But when they entered, they found the temple completely ransacked by the Greeks.

It fell on the high priest to cleanse and re-consecrate it, as well as to light the lamp. There was only enough oil for one day, but it miraculously lasted for eight days – long enough to obtain a new supply of consecrated oil. The lamp was lit, the temple re-consecrated and the high priest, the priests, the Maccabees and the people celebrated. Lest they forget, the high priest proposed that the Jews commemorate and celebrate this miraculous event at the same time each year in the month of Kislev (December).

Hanukkah starts on the 25th of Kislev every year and lasts for eight days. A lamp with nine branches is lit, one candle for every day of the celebrations and the ninth to light all the other candles. Every day an extra candle is lit and all nine burn on the last evening. And while the Hanukkah lamp is by the window burning for all the world to see, inside the homes families play games, eat special foods and unwrap presents. Hanukkah is also a time of going to plays and concerts in synagogues and schools.

Its hallmark puts 'my' Hanukkah lamp in the city of Vilnius in Lithuania. A large group of Jews – mostly traders, artisans and merchants – had made their way to this country in the 14th

century, many of them at the request or invitation of August II and August III, Kings of Poland and Grand Dukes of Lithuania.

The Jews of Lithuania built their first synagogue in 1440. Most of the country's synagogues were Moorish-style buildings with 'A house of prayer is a holy place for all peoples' inscribed in Hebrew above the door.

When war broke out, Lithuania had 105 synagogues and prayer houses and Vilnius was often called the 'Jerusalem of Lithuania', as the city had some 100,000 Jewish residents, around 45% of the city population. For the country as a whole, this number stood at 240,000.

Vilnius was hard hit by Nazi Germany, and the Jewish community was devastated, reduced to just 22,000 after the war. Today, some 6,500 Jews live in Lithuania, around 5,000 in Vilnius. The Germans murdered around 95% of the city's Jewish population. In July 1944, the city was liberated by Poland's *Armia Krajowa* (Home Army or resistance movement) in what has gone down in history as Operation Ostra Brama. The Nazi German occupiers of Vilnius were finally defeated on 14 July 1944. The Soviet Red Army marched in the next day.

Dr Frenkel, how was I to know that a piece of antique silver would teach me so much about a history I had absolutely no idea about? I've long since discovered that cultures and religions will often come together in art.

The two peacocks on either side of this lamp represent the

wealth of King Solomon, a story also told in the Koran – which is why I initially assumed I was dealing with Islamic art in this piece. My research unlocked a great many cultures and religions in a single, beautiful silver object, presenting me with a haunting tale of human repression and freedom.

My research into the events in Lithuania and particularly in the city of Vilnius gave me nightmares. I was so affected by the horrors I uncovered that I became unable to sleep and got really worried about my family, about the future of my children in my adopted country. I was walking around half-crazed, and people at work noticed how deeply I was affected – all by these events in Lithuania so many years ago.

I remember my boss asking me how I was doing one day, after finding tears streaming down my face. I told her I'd become very fearful, that I thought everyone was looking at me when I was walking down the street. For the first time since I moved to the Netherlands, I felt that people were thinking "Look, there's someone from an ethnic minority." It was a strange and unsettling experience, because I'd always felt at home in the Netherlands.

"It's like I'm living in another time," I told her. "I'm right in the middle of a war, I'm in over my head and it hurts." My boss was really concerned about me and offered to help where she could. She didn't want me to go through this alone.

Even today, when I look at the Hanukkah lamp, I remember how it survived the war. If only it could tell me its story.

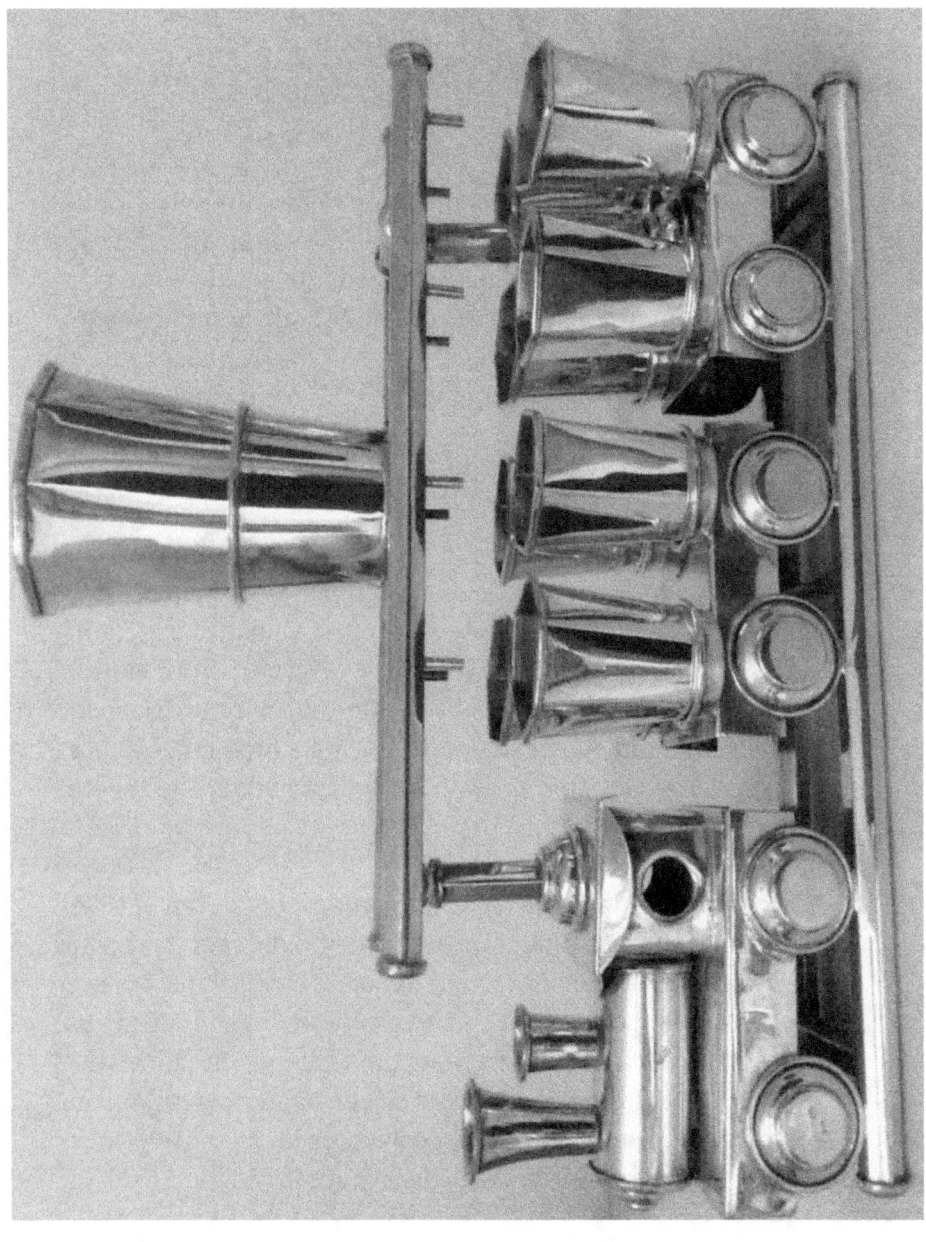

3. The Kiddush train

The next piece from my collection is a beautiful silver Kiddush train. This unusually designed Kiddush fountain has the usual eight small cups topped by the large Kiddush cup – but this time the eight cups are in the shape of train compartments, four on the right and four on the left. Wine is poured into the large cups and then distributed into the eight smaller cups by means of a set of tubes. I was impressed by its craftsmanship and have a story to share about this Kiddush train.

The summer holidays were nearly upon us, I remember, and my wife and I were about to leave for a holiday in Egypt. We were planning to drive or take a bus from the Sinai to Jerusalem – a trip we'd been looking forward to. A colleague from work stopped by about a week before our departure to take a look at the pieces I had collected and to tell me a little more about them, as he is much more knowledgeable about the Jewish people and their culture than I am.

I showed him many pieces, among them this stunning silver Kiddush train. The only thing was, I just didn't get its message. It looked like it had been commissioned or perhaps it was an apprentice's 'proof piece', as it was clearly handcrafted and lacked the usual hallmarks that could have pointed me to its maker and country of origin. However, the train was made of first-grade silver and I told my colleague I was considering selling it to silver traders as old silver, as it weighed nearly a kilo

and we needed money for our trip. And besides, I didn't really get the meaning of the piece – this was a very oddly shaped Kiddush set.

Visibly mesmerised by the piece, my colleague thought hard for a while and then looked up at me, surprised. "You really don't understand?" he asked.

"No, I truly have no idea what it means."

There were tears in his eyes now as he told me what he thought it meant in a sad voice.

"It's a sarcastic twist on the Kiddush fountain," he said. "Trains have become a symbol of death. German railways and railways in the occupied countries played a key part in transporting the Jews to the concentration camps."

Noticing my blank stare, he went on to tell me that the concentration camps had been set up alongside railways and that the Jews had been taken to them from all corners of Europe – one way of course.

Right from the start of the war, freight trains were constantly running to the concentration camps. Thousands of people, including soldiers, would see the long lines of goods wagons waiting at train stations, with the faces of the thirst-stricken deportees looking out at them through small air holes covered with barbed wire.

In fact, the Jews were deported in closed cattle wagons, initially taking about a hundred people per wagon and later around 150 or even more. The doors would remain locked all the way to the death camps and no food or drink was provided, causing many to die even before reaching the camps. There were guards on every train and they would shoot anybody who attempted to escape – some of the deportees were well aware of their destination and tried to get away. Only a few of them managed to escape from what was a virtually certain death.

To transport as many Jews as possible in one go, these trains were extremely long and heavy, which meant they moved slowly and had to give way to all other trains. What's more, these trains were often ordered to take the long way round and some of them took 50 hours or more to get from Germany to eastern Poland. In the hot summer months, death was their passengers' constant travel companion. The war's longest transport, from Corfu, took 18 days to make it to the camps. All of the deportees were dead on arrival.

I learned that that on one of these trains the Germans even put Jewish psychiatric patients from an institution in Apeldoorn in the Netherlands, as well as disabled boys and girls. All of them met their deaths in Auschwitz.

Incidentally, I discovered that the Roma people were also persecuted. These nomads originated in India and travelled to all parts of Europe, where they also became known by the somewhat pejorative term 'gypsies', from the Spanish *gitano* meaning 'Egyptian', owing to the belief, common in the Middle

Ages, that the Roma were itinerant Egyptians.

After the war, death camp survivors were expected to pay for their own train tickets home. In 2010, the chief executive of France's rail company, SNCF, apologised for his company's role in the Holocaust and admitted that SNCF had served as a 'cog' in the Nazi machine of extermination in the Second World War. Speaking in Bobigny, a place from which in 1943 and 1944 precisely 22,407 Jews were sent to internment camp at Drancy in 21 convoys and then on their way to their deaths in Nazi extermination camps, Pepy expressed "profound sorrow and regret" for SNCF's role in the deportations of French Jews.

My colleague explained the importance of the Kiddush ceremony and the related Kaddish prayer for the souls of the dead, and how this Kiddush train was a clear symbol of death. Immediately realising how ignorant I had been, I assured him that I would not now sell the train but rather give it pride of place in my collection.

I'm truly sorry, Dr Frenkel, that despite my many years at school and extensive university training I knew so little about the Second World War, and nothing at all how trains had been used to transport the Jews – a history that had been kept from us. Schools in the Middle East are taught about the Jews in the context of the Arab-Israeli conflict, and our media portray Nazi Germany as heroic. Only now, many years after I moved to the Netherlands, am I finding out what truly happened in the war, bit by painful bit – a whole community laid to waste along with other ethnic minorities. This gruesome past has made me very

worried about my own children's future.

We left for Egypt two days later, to the beautiful Sinai and Red Sea area. I was agitated. I found some distraction in our daytime trips but was visited by nightmares at night, seeing myself and many others being pushed into cattle wagons on our way to the death camps. Several times I woke up screaming.

The holiday also saw us take a bus to Jerusalem, where we spent two days – a trip that with my new-found knowledge somehow become even more impressive and awe-inspiring.

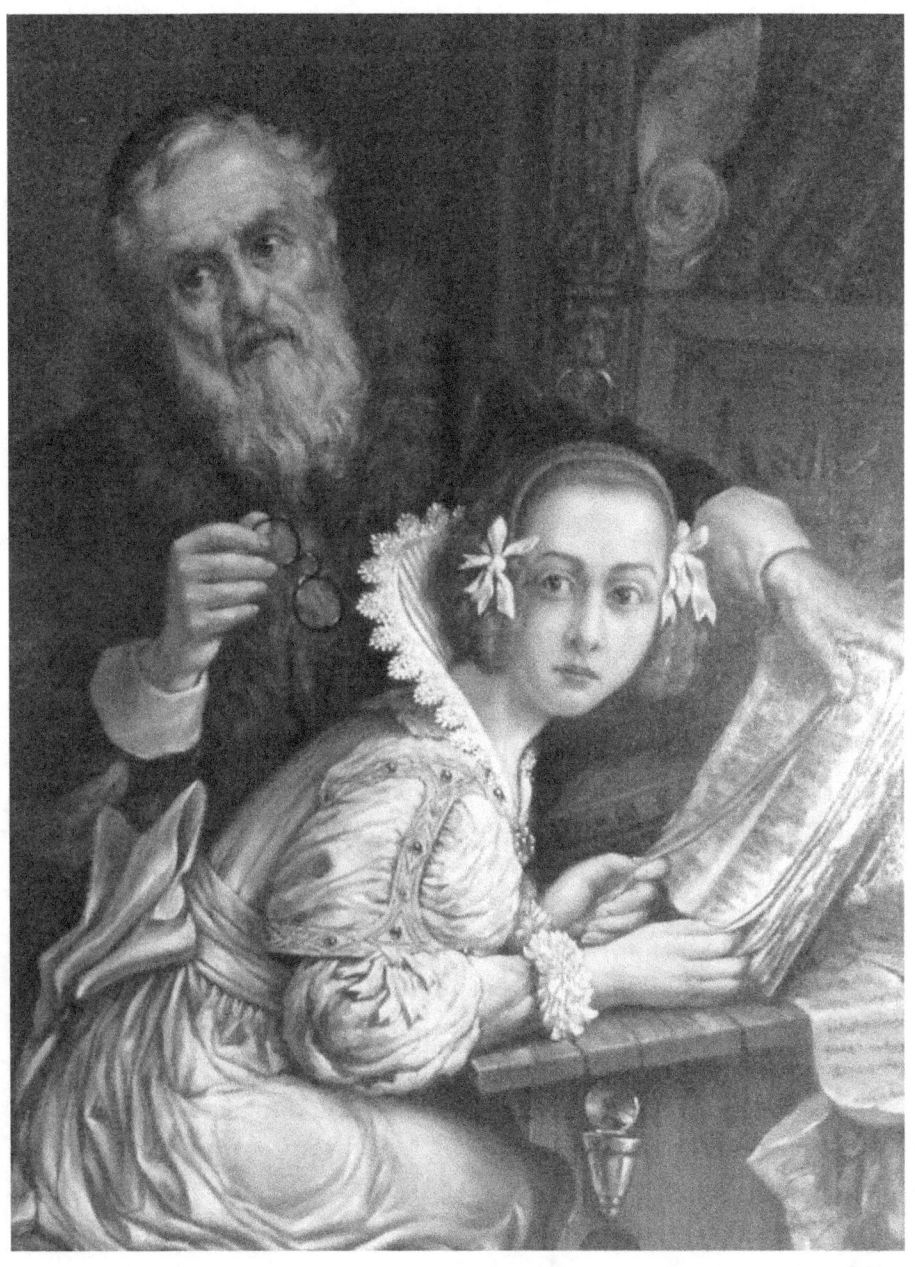

4. The painting

The next piece in my collection of artworks is not silver, but a gorgeous, large painting of a Jewish father and his daughter reading or studying a book. It's by Belgian painter Lucien Stuyts (1879-1962), oil on canvas.

Dr Frenkel, I was in the office one day when I heard a striking voice in my head saying: "Get up and go to the De Looier antiques market, there's a man and a woman waiting for you." I thought I must be hearing things and was probably just tired – it was clearly time for coffee.

The voice came to me again, though: "Get up and go to De Looier, there's a woman and a man waiting for you."

I got up, put my coat on and popped over to De Looier. Whenever I go there, I typically only look at any silver pieces that may have come in. I know almost all the traders by name.

When I walked inside I felt something really out of the ordinary, something I'd never felt before. I was really, really curious about the man and woman waiting for me there. While looking around for them, my eye happened to fall on a painting ready for auction. I don't normally pay much attention to paintings for sale at De Looier, but this time I took a closer look. I saw that it depicted a Jewish man and a young woman, beautifully captured. I asked the auctioneer if I could take a closer look: a painter in my spare time, I wanted to see whether it was real oil on canvas or merely a print. It proved to be hand-painted.

I felt it was a beautiful painting, a museum piece – it really drew me in. I didn't even look at the price, I just asked the auctioneer to wrap it for me. When I didn't hear the voice again, it slowly dawned on me that the man and woman waiting for me must have been the painting's subjects, the Jewish man and his daughter. I was really pleased with my purchase; we did a good job of cleaning it and hung it in our living room.

I would often catch myself looking at the painting and decided to find out more: where it came from, who had painted it. It was so vibrant and real, I kept forgetting it was a painting. It felt as if both father and daughter were constantly looking at me. They followed me with their eyes wherever I was in the room – it looked as if they wanted to ask or tell me something. They appeared surprised, as if they wondered who I was and how I had ended up in their lives. But it was me who had no clue how they'd shown up in mine.

The longer I looked, the more I noticed on the canvas. On some days I was even afraid to look at these people. One day, the girl started talking to me.

"Hi, do you recognise me?"

"Yes, I've seen you before. In my dream, when we were visiting the Sinai desert."

"That was not a dream, you really saw me, in your invisible

world."

"What? What are you telling me?"

"Didn't you know? You live in both a visible and an invisible world, and the minute you fall asleep you enter into the invisible. You'll often not remember much, as your head's very busy processing daily concerns. Occasionally, you are aware of goings-on in your invisible world; you think you really see people and do things you might also do in your visible world. And then, when you wake up, you realise that there's another, even better world alongside the one you live in everyday; it's your dream world."

"You really frightened me at the time, it was like a dream within a dream. I thought you were my wife beside the bed, checking to see if I was asleep. I wanted to reassure her by pretending to be asleep until I felt her breath on my face – that nearly gave me a heart attack. My dream was rudely interrupted by my wife, who woke me."

"I was curious as to why you were visiting the Sinai desert and why you wanted to go to Jerusalem."

"I found it fascinating to go where many of my forebears had gone before, on foot, by camel or on donkeys, and the actual bus trip to Jerusalem through the desert was incredibly impressive. Let's not forget that the city of Jerusalem appeals to many people for religious reasons. Words cannot express how I felt visiting its churches, the Wailing Wall, synagogues

and mosques. To wander along its small, crooked streets packed with galleries and low doors, its shops sometimes only a few metres deep with doors instead of windows, and its owners sitting beside these doors to invite visitors in. I imagined it to be like pre-war Vilnius, the province of 'my' Hanukkah lamp.

It was a very special experience to approach Jerusalem from the mountains, and I was one of the few Egyptians that came to visit the city, as the Arab-Israeli conflict stops most Arabs from visiting Israel."

"What were you looking for in Jerusalem?"

"To be honest, I didn't really know at first. But it gradually dawned on me: it was me I was looking for, me I needed to find, explore and get to know. Who was I? Why was I here? Born in Egypt, I had moved to the Netherlands. Why? There must have been deeper reasons; I refused to believe in happenstance.

I was also looking for God. Not from a default perspective but from a kind of freedom in my head. What I mean is that I wasn't coming at the experience from a specific system, culture or any other type of pre-programming. I believe that people in all cultures are programmed to fit in and that all programmes are different. My journey offered me space, an absence of preconceived ideas, of programmes. And I found myself looking for God: Where is God? Who is God? And what is my relationship with God?

I was born and raised a Muslim, and have a great deal of respect for other people's faiths. Faith should bring people closer, as God is love. In fact, God is life, as I've discovered. I was moved by my visit to the church in Jerusalem, by lighting candles there; I was moved by my visits to the Wailing Wall and synagogue; and I was moved by praying at the Jerusalem mosque.

I was in Jerusalem and I was looking for God. I was looking for God in the people around me, in plants, in the mountains, in the birds, in everything really. It was a search that completely dominated my life. And I found God. In Sinai and on my journey to Jerusalem, I found God. I found that God is in me and in every other human being and in everything around me. I discovered that a spark of God, a God-like power is in all things and beings. It dawned on me that it was up to me to find that God-like power in myself. And not just in myself, in every human being and in everything else in the universe. The bolder my search became, the more I saw the meaning of life. I began to believe that all things are possible for every single human being."

"Good, Ebrahim, you're actually beginning to understand a little about life. You're right, creating space in your head is essential. The greater the space, the more insight and fun life will bring. Find out who you are, find that God-like power in yourself and all around you, and create your own story in life. Don't forget – your world is your story. There are many who are able to describe what happens, but they're no more than passive

onlookers of their own existence. Others actually see themselves in what's going on and play a more active role in their lives."

"I started to understand why my life had taken me to the Netherlands: I needed to learn a different 'programme'. I've discovered that all countries use different programming to guide the masses, as these systems vary from one country to the next. Handling differences of opinion; respecting other people's views and ideas; conferring with each other and asking people for their input – just a few aspects I learned in the Dutch programme. The things a country's children handle with ease are inaccessible to adults operating in different programmes. So what are you doing in that painting? Are you reading?"

"Yes, I am. I'm reading a book by Petrus Cunaeus: *The Hebrew Republic*. We may excel at many things but aren't allowed to practise many professions as we're Jews. I'm studying and everyone's a nuisance that walks in on my father and me. And what are you up to?"

"I've collected a range of silver pieces that I think are very special, and I've decided to investigate where they come from and then write something about them. In fact, I want to write a book about my silver collection, I want to show that we can evoke an entire history through a single piece. Antiques aren't just objects, they're heritage representing a community's history."

"That's fascinating. I wonder, though: why only silver? Why not

collect documents, paintings and other old objects? Wouldn't they be a great addition to your collection and story?"

"You know what the problem is? I'm not a writer. I find it very hard to put my thoughts to paper."

"That shouldn't be a problem, just don't overthink it. Just start somewhere and let your thoughts do the work for you – it'll write itself, you'll see."

"How about this: my idea is to write my story in a letter to Dr Frenkel, the surgeon who operated on my knee and who I consider to be a friend. He was the first to ask to read my story. Dr Frenkel has come to represent everyone who reads my story or, conversely, I see everyone who reads my story as a Dr Frenkel."

"Interesting."

"What's your name?"

"I'm Channah."

"And where do you come from?"

"Channah, Channah."

I woke up to my young daughter calling me. "Daddy, Daddy – wake up Daddy!" she said. "Do you want to read a book together?"

"Yes, darling, let's read a book together."

A beautiful dream. I have no idea where that name 'Channah' came from, but have since found out that it means 'grace'.

I saw myself as the father of the girl in the painting, enjoying chatting with her. A father who wants to teach his children, only to find out that they're incredibly wise already. They notice the programming everywhere, in cultures, countries, peoples. I used to worry about my children's futures but no longer: thanks to today's super-fast communications they're in control. They have another take on the world we live in, understand how all these programmes were created to guide the masses within frameworks and standards. In fact, they create their own programmes and are much better at communicating than we ever were. They'll be fine: they understand that no age is like the other, but understand that the story of humanity is always the same.

POLITIEKE OPSPORINGSDIENST
ROTTERDAM

ROTTERDAM, 22 Juni 1945

Het Hoofd van den Politieken Opsporingsdienst te Rotterdam verklaart, dat ten aanzien van de politieke betrouwbaarheid van

[redacted]

(Persoonsbewijs [redacted])

niets nadeeligs bekend is.

Het Hoofd van den Politieken Opsporingsdienst.

5. The diary

The fifth thing I'd like to share with you from my collection is an extraordinary diary kept by a Rotterdam man who went into hiding during the war. After my experiences with the painting, I'd decided to cast my net wider than just silver. And one day, while trawling the buy-and-sell websites for old postcards, letters and so on, I came across a document called a *Dagboek* ('diary'). The seller had found it among the household effects of a deceased older man in the south of the country.

I was very happy with the diary, as I'd never had my hands on a historical document of this nature. That said, when I received it, I immediately noticed I had a problem: I couldn't read the longhand. A co-worker of mine, Jan Roos, ended up doing that for me – he said it was a challenging job indeed. The diary came with a certificate of good character issued by the municipality of Rotterdam. The diary's author had needed it to land a job after the war.

Diary of Meijer Frenkel, born 27 June 1910
Household address: Noorderhavenkade 92B, Rotterdam

5 November, Day 1

My dearest,
Shortly after you left – they left our home after midnight – our horrible misfortune began to sink in. Half crazy with grief I walked through our home, our home desecrated by the rough

steps and hands of the intruders. How grievously did I feel then how much you mean to me. I walked round and round until it was clear to me that I needed to leave. I kissed everything you were wont to touch, things you have taken such great care of. Things that felt dead and dull without you to look after them. It's not things we pine after in life, it's the spirit that brings them to life.

I have no idea how long we'll be apart and I don't know if we'll both survive this ordeal, but I do know one thing: whatever happens, I will never regret our time together. We've been given two years of riches, two years that will soon be beyond reach but that exist and will sustain us.

I'll write to you every day and you will read this when we awake from this bad dream. Plain and unchangeable, straight from the heart, these pages in my diary will tell you of my worries, my longing and love for both of you that I had to leave behind.

And by the time you do, my sweet, times will have changed and we'll be looking at the better future that we so deserve.

6 November, Day 2

There hasn't been a single moment when I've not thought of you, neither in the day nor at night. How I long for my beloved with every fibre of my being, body and soul. How unhappy you must be and God knows what humiliations you're going through! I try to imagine where you are but I can't. How you'll hate the daily agonies! The food you haven't prepared yourself, the sheets you yourself didn't clean. Wife of mine, I pray you'll

have the strength to pull through. Powerless as I am, I have to submit to the situation; sending or receiving any sign of life is impossible. The only thing we have and must have is faith, deep within our own hearts.

7 November, Day 3

My dearest love, yesterday I wrote about faith, but today I don't have much of it. I'll be leaving here, destination unknown. No idea what dangers await me, what house or shack. My thoughts are with you all the time, both of you suffering because of me. Whatever anyone may say, I will repay what I owe you when I return, will gather unto me all that you've been through. I want to be there for you, be better than I know how. Never again will we turn little things into major problems.

If I get a chance, I want to build a life with you and make sure it's worth living. I want to work for your upkeep, live with both of you together. Nothing will ever take me away again from where I belong, my family, who I miss more strongly than ever before.

8 November, Day 4

I've now arrived at a temporary destination and have found some peace and perspective. I'll only be able to write about you in my diary, as I have no idea who might read it and in what way. But dearest, even if I didn't write, there wouldn't be a moment that I wasn't thinking of you. Not the way I used to when away from home, a brief thought just before going to

sleep, no – all day and much of the night. I keep seeing your sad eyes that'll be crying more than ever now. And yet, my darling girl, I'm convinced that the day will come that I can make up to you for all your sufferings.

9 November, Day 5

It isn't the length of these letters that matters, my dearest, but their content. It's so hard to entrust paper with all these very intimate thoughts. Do you remember how I once refused to read a passage from a book to you because I felt it was simply too ardent? Every word you read in my book, my dearest, represents thousands of others. You'll read of longing and love for you and the child over and over again – how it's written does not matter. And I'll also keep writing of my hopes that we'll be together again one day soon.

10 November, Day 6

It's this state of not knowing, my sweet, that made me think of you all day today. Not knowing where you are, what they've done to you and what else you will suffer – that's truly the worst of it. How I wish I could console you, kiss your eyes red from crying, how easy it would be to bear my lot. When, oh when?

11 November, Day 7

Today, my sweet, I spoke to you. You felt so close at dusk when all I'd been doing was think of you. I felt your hand, I felt you

tremble but you talked of courage and used the words I've so often spoken myself. I knew I was imagining things, perhaps I was dreaming. And yet, however much naysaying my mind gives me, my senses and heart believe that you were with me. You probably won't believe it of your ever-sensible other half, but it gave me comfort and strength.

12 November, Day 8

My precious, I don't want to lie to you, not even on paper. Dark thoughts and suspicions are going through my mind. I've heard a few things, not specifically about you, but it was enough to shake me to the core. How could we help loving each other so dearly? Will you ever regret it, my sweet, won't you find your sufferings too high a price for such a little bit of happiness? But it wasn't a little bit, was it, my darling? We meant so much to each other, even more after two years than when we were first together. How I wish you were here to reassure me.

13 November, Day 9

My unease and distress over your sufferings haven't lessened or faded. How long will I have to go on not knowing? My beloved, I'm in the easiest position of the two of us, under what kind of circumstances are you grappling with your doubts? That's what worries me the most, my darling, not your thoughts or desires, I carry those with me always, it's where you are and what conditions you're living under. I have a really bad feeling about it.

14 November, Day 10

It's wonderful and strange at the same time how you're constantly with me. And it's not that I sit down to think about you – it's as if you're constantly talking to me and I to you. I really don't know how to explain this. Actually, the less emphatically I think of you, the more you just 'happen' to be with me. You comfort me and you make me sad. You give me strength and you bring doubt, but whatever emotion you evoke – it doesn't matter, as you're with me all day.

15 November, Day 11

I've thrown caution to the wind, my darling. I've gone against all reason and passed on a sign of life. And now the doubts have really started. Will you receive the message, will your circumstances be such that it reaches you? When will I hear something from you? How often have I comforted you when you were really sad, please come and do the same for me. Your other half needs you so badly!

16 November, Day 12

I wonder whether you've received my message. How much lighter will be the load if you have. I've prayed for it to reach you to reduce any doubts you may have. Every hour of the day I try to think of ways to get some sort of message to you. Not to tell you how much I think of you, or what I feel, just to assure you that we're both still alive. Life has taught me to be satisfied with very little and has shown me how rich were our days

together.

17 November, Day 13

If all's gone well, my darling, you should have heard something from me today. How I hope you have! My main concern isn't so much my own discomfort but the unease you might feel about me. I wish I could offer some comfort somehow. Will that time come soon? I really can't do without you, my sweet, and yet we have to. I'm grateful for being safe but torn over our separation. And yet, I could handle all that if I was sure that you and the boy are well. How easy things would be if I knew that for a fact. But when will I be sure?

18 November, Day 14

The day isn't done yet, but I can't wait: I just have to talk to you about the miracle that is love. That I love you and how happy that makes me feel and how much pain that causes at the same time. Perhaps that's the difference between love and joy, both make me happy, but love hurts at the same time, as its joy also comes with worries about those that we love. Perhaps I'm writing nonsense, but even my nonsense should show you how much I love you. You're everything to me. You're with me and are looking at me whatever I'm doing. In my mind I hear your sweet, sweet voice, see your lovely eyes. My darling, in my thoughts I take you in my arms and embrace and kiss you time and time again.

19 November, Day 15

My sweet, what should I tell you today? This letter as much as all the others will be about my doubts and discomfort about your fate. How we pay for our happiness! My dearest, it doesn't really matter what's happening to you or me, as long as it isn't irreparable. The future is ours and will be happy. Remember how you sacrificed everything for the three of us to be together? Ever since we parted, I haven't once doubted our happy reunion one day. Darling, the many wonderful and happy years ahead of us will pull me through this time right now.

20 November, Day 16

I mentioned doubt yesterday, my darling, and I'd like to make clear what I mean to avoid any misunderstandings. I have no doubt, none whatsoever, about our happiness after the war. In a material sense, I'm also confident we'll be able to buy what was taken from us. My doubt is this: will you find the inner strength to hold firm against those who threaten you? You, who has always found it impossible to lie, who went through life totally open and honest, you must be having such a hard time dealing with people that try to catch you out on every single word, that look for different words behind every other word. O, my sweet, I wish I could be there for you now. And yet, deep down, I believe in a better future, I refuse to believe that all your sacrifices have been in vain. I wish I knew just a little about where you are and what you're doing, how much easier this would all be.

21 November, Day 17

Just this once, my darling, I'll not talk about how much I long for you and about my worries about you. I want to tell you something that's been bothering me. I know you won't hold it against me, especially as we agreed this would be the best thing to do. But wise though it may be, I do regret taking off your ring. I can't tell you how much I miss it – my fingers keep going to where it used to be whenever I think about you. I never talk about you here, for more than one reason. I don't want people to feel sorrier for me than they already do and, besides, there is no need for them to know too much about me – I've already paid too high a price because of that. But I make up for lack of speech in my memories, I constantly think of all those I've had to leave behind. Ineke will have grown so much by the time I return, she's bound to be able to talk by then.

 My darling, I have so much to make up to you. And I will, whatever it takes. Everything I do, say and think will be about creating a better future for you. Not riches, my sweet, but our love for each other. Living together, enjoying life together, going through life together to help each other forget the misery we've suffered. That's what I've promised myself and that's the promise I'll keep, whatever life throws at us. Enough for today, my sweet, an ardent kiss for you!

22 November, Day 18

My dearest, I have no idea whether these diary pages have become similar and repetitive. I made a vow to myself not to read them after writing and not to change them while writing.

One day you'll read them and I want you to read my words exactly as and when I wrote them while thinking of you. My words may be clumsy one day, and perhaps sound slick the other, but at least you'll be able to read that I longed for you and Piet every day since our separation and that I needed to write of my overwhelming love for my family. My dearest, such a good life we had, perhaps even a little too good – I don't think we were always aware of the many that were suffering while we were happy. My sweet, let's try and make others happy as well as ourselves once we're together again. I have no idea how, but I'm sure that together we'll find a way and the resources to do so.

23 November, Day 19

Darling, I long for a sign of life from you but there's no way for me to contact you. I would love to write you a long letter to comfort you and to tell you what's in my heart, but alas, this is not the time. Let me assure you, then, that you have again been on my mind from the minute I woke up until the evening, and that I don't really have the words to tell you how much I miss you and what you mean to me.

24 November, Day 20

Tomorrow, my dearest, I will send you another sign of life and take comfort from the thought that you'll hear something from me at least. Assuming, my love, that you are in a position to receive it – it's this fearful doubt that is torturing me, that makes me lose weight and heart.

My sweet, I wish I was there to help you, to strengthen and comfort you. How long will we have to live separate lives, longing for each other, worrying about the other? Let's just hope, my dearest girl, that we'll both manage to pull through.

25 November, Day 21

I'm sorry, my darling, I can't help it: I'm thinking sad thoughts, just like yesterday and the days before. Who wouldn't cry and despair in our position? One comfort remains and that's the love I feel for you, which merely seems to grow as I encounter more trials and tribulations. I keep hearing your beloved voice supporting and encouraging me. My dear heart, I wish I was stronger than I feel right now, how small and doubtful the strong can be in the truly difficult hours. I'm not going to apologise, as I cannot tell you about the circumstances that have made me so. Later, my sweet, when we're back together again, we will tell each other all, give each other comfort and cheer. It's off to sleep for me now; I'll be thinking of you in my arms as always and will whisper to you all that I used to. Night, night, my darling.

26 November, Day 22

My dearest, should I speak of sorrow and fear again today? No, let's not: you would think there was nothing else when you finally read this. Today I want to do no more and no less than sit with you before going to sleep and picture you with me. You won't regret all that has happened, will you? On the contrary,

my sweet, you will long for a future that will bring us together again. I know, know, we've both made mistakes – particularly me – but at the two years' reckoning I can look you in the eye and say that we were doing well together. Both you and me. This honest conviction gives me strength in today's darkest hours and in the many dark hours still ahead of us before we are again as one.

27 November, Day 23

Darling, I have nothing new to report but I still want to write to you today. I don't just want to think of you every day, I also want to share what's in my heart and mind. Will all my letters be nearly the same then? I hope so, my sweet, they're bound to be similar, as they bear testimony to my abiding love for you and Piet. It doesn't matter, love. Maybe you'll never actually read them because there'll be so much to do about our future when we're together again that the past will get left behind. But if you do ever read them, there'll be one thing that stands out: how much I love you and how we belong together.

28 November, Day 24

Darling, I feel very sad today and some of it may seep into this letter. The more time I have to think about it, the guiltier I feel about what happened. Looking back, I have no idea if everyone knew how big the risks were, but that's too easy. I know, I know, there's nothing I can do about it until I'm finally able to kiss the tears from your eyes and to surround them with all the love and goodness you deserve and that I'm desperate to give

to you.

29 November, Day 25

My dearest, I dreamed about you! Not for the first time, but never with such clarity. You were in a cell sitting on your bed and were combing your hair. I noticed how it had gone grey. You looked very sad and I remembered the poem (you never liked poetry) that I read to you once, about the man whose wife was rounded up in a raid and who never heard from her again. I now know how the poet must have felt and even you would feel it differently now. One thing will be different, my dearest, as you and I will see each other again, and there will be no new separations for us, no fear or agitation, just beautiful mutual love and courage.

30 November, Day 26

My dearest, I can't remember whether I've talked to you about what I just realised. It's about this daily letter to you, about why I do it. Why do I write to you every day? Not to prove that I've really been thinking about you all the time – you'll know anyway. I write because I feel this desperate need to be with you every day and every hour, to tell you what's going on inside of me. If you ever get a chance to read what every day of our separation brought me, it'll hopefully give you some comfort for all the fear and sorrow you've been through, and courage for the future, for our future.

1 December, Day 27

A new month has begun, my dearest, and the last of our separation if I'm not mistaken. Now that it's getting colder you'll probably miss your other half even more. My sweeting, how I wish I was with you, could make your hot-water bottle for you, keep the bed and you warm at night, and the three of us enjoying winter evenings huddled around a hot stove. My dear heart, we had such a good life together. Let's always remember that once we're together again. Let's at least try, shall we?

2 December, Day 28

My sweeting, it's probably because of the preparations for the holiday season that I've been so sad today and the last few days. I find myself changed in this, too: in the future we will also participate in such home celebrations and spend lovely days preparing and having fun before the event. So you see, my darling, here's some progress in myself: I've lost some of my dourness and am looking forward to enjoying the small things that I used to think were nonsense. Is there a truth in the commonly held belief, then, that sorrow changes people and that suffering is never in vain?

3 December, Day 29

Darling, today is the second anniversary of the start of the most difficult time in our lives. You won't be surprised to read that I cannot think of anything else. You were so brave and strong, and managed to overcome all adversity. The memory gives me

hope that we'll manage to pull through again. I know it's hard now, but we didn't know it then. Two years on from now, I'll make sure no traces of worry and sorrow will be left – let this promise be enough for today.

4 December, Day 30

My darling, it may be that I've talked a little less about my feelings for you in these past few days and a little more about what was going on with me. I'm sure you'll forgive me, my dearest. It isn't what I write that matters, but what I'm trying to express in words. It's the thought behind the prose that counts, and I'm sure that's exactly how you will read it one day. Time and again, you'll read about my desire to express and act on my great love for you.

5 December, Day 31

My love, I won't be writing a lot today. The festivities are in full swing downstairs and I'm up here crying. I suppose it's the same for you and all of us who suffer. There's still so much suffering in the outside world and this is the first time we're actually experiencing it first hand. Perhaps this is the way it's supposed to be, perhaps it's the only way life teaches us. I won't write any more, darling, but before I go to sleep: goodnight my darling, goodnight my dearest, talk to you in the morning.

6 December, Day 32

It's not a cold day today. These days, I'm even more pleased with every nice day than I used to be. You and all others suffering can do without the cold. And yet, I feel that anything coming from the outside does not decide what's on the inside of us. If we manage to hold on to the courage to live, trust in the certainty of happiness to come, no cold will harm us. Our memories and former happiness should be a strength and support, for both of us, don't you agree?

7 December, Day 33

My dearest, today I'm not just sad, I'm happy. I've heard something for the first time. Not about you exactly, but a little titbit of information that reassures me that there's no danger of irreversible things happening. The only thing it'll take now is the courage to live and faith in yourself – and you have plenty of both. Think of your beloved, sweeting, as I'm thinking of you – it reassures me and points the way to a happy future. My darling, I feel so reassured today.

8 December, Day 34

My dearest, it's been five full weeks since our separation started. How many tears you must have shed, how many fears you must have faced. Whenever I think these thoughts, I get really sad and picture the most heart-rending images in my mind's eye. I tell myself that my fears are getting the better of me, that I'm just making it worse, and yet my concern isn't dissipating. And it's unlikely to until I'm with you again. I have

no idea how long this will go on for, but that happy moment will come and it is that certainty that makes me live.

9 December, Day 35

Darling, today is a colder day and I'm cold too – perhaps that's why I'm a bit gloomier than usual. We've never been parted for this long since we promised we'd stay together. We thought we wouldn't be able to cope, but when necessity strikes... Are we able to cope because we have to or because we have faith in each other and never forget each other for one minute? The latter, I believe. Love is a strange thing, my darling, but over the past few weeks I've found that it can make a person stronger. I hope you also find it so.

10 December, Day 36

My dearest, how long before we're together again? If only you knew, my love, how sad your man is every day and how life has lost all meaning and purpose without you. I know, I know, I have no right to complain, many people are living in much worse circumstances – perhaps even you. And yet, I'm so fed up, there is so much I want to talk to you about and so little I can actually put to paper. Every evening, my love, after writing these few lines I silently beg you not to leave me. I need you so badly.

11 December, Day 37

My sweeting, I just know you won't believe me if I tell you that I

think of you and Piet all day, every day. And yet it's true, you are always at the forefront of my mind in every step I take and every move I make. Or maybe you will believe me, as it was no different for you. Darling, I feel so empty sometimes and I get headaches just thinking about you – it's almost as if I'm losing my mind. I just can't live without you and yet I have to – how can I go on?

12 December, Day 38

My darling girl, I guess I'll just write it down: I've been unable to sleep for a week, I'm so concerned about you. Where you are, what you're doing, what's going through your mind, I can't seem to stop the thoughts day and night. I wish I knew what was going on, that I could let you know how I'm doing and could hear from you. How big a price we're paying for our happiness, my darling, won't you think it's too high a price to pay?

13 December, Day 39

I so dread the holiday season without you, not being in our home. I often feel like going to sleep and not waking up until it's all over. Darling mine, you must know I'm no longer who I was. I make no plans for the future, I have no wishes or desires except for that all-encompassing one: to be with you. For the three of us just to live together and keep all the storms outside. It's so little that we want from life, my darling, and yet it would seem to be too much. I'm so sad, so horribly sad about our fate.

This is where the diary ends.

Dr Frenkel, I was deeply touched by this diary and resolved to look for information about this particular family. Much to my surprise I was unable to find anything – I had hoped to find out whether the mother and child survived the war by paying a visit to the Amsterdam-based Jewish Historical Museum. But they couldn't help me and nor did the city of Rotterdam have any relevant information.

The diary completely changed my life. I remember the lady at the Jewish Historical Museum going through the records with me and trying to find out what had happened to this family, tears streaming down my face.

I heard a voice in my head: "You want to know what has happened to your family, you're Meijer Frenkel but you still don't know whether your family survived the war."

"You could try and search by address," the museum official said, but we have no records about this family."

When she and I went through the material by address, we saw that many families at Noorderhavenkade in Rotterdam had been rounded up and deported. There was no information about 92B. My head was exploding: how could I find them, how could I find out more about this family? The many voices in my head wouldn't leave me in peace: "Keep looking, you have to

keep looking for your family."

These voices in my head, they're driving me crazy – I really need help, this is turning my life upside down. I left Egypt with the same dreams as any other immigrant: to make lots of money and lead a life of luxury. Little did I know that I would be encountering this history – I dream of it all at night.

I can't seem to stop these thoughts. I come from a culture that's all about tomorrow: "Tomorrow I'll do this, tomorrow I'll do that." My life has changed completely: I'm no longer looking at tomorrow, I have no big dreams any longer, no desire for a life of luxury. All of that's gone, vanished. I live now, I am in the moment, that's all that matters.

Dr Frenkel, I'm really tired and really sad, and the voices won't leave me alone. I don't know what to do. I'm starting to believe that I actually am Meijer Frenkel, that I'm desperately looking for my family.

And so I continued my search.

Afterword

The road to antique silver drew me into a world without borders, a world without programmes. What started off as a bit of a joke – to try and sell a silver coffee set to Queen Beatrix – took me to the depths of a community laid to waste.

My journey went so deep that I actually felt I was living at the time of the Second World War, that I was living through a time of devastation. It has made me rich beyond words, as it taught me what really matters in life. I've learned that life is all about now and that my life is all about me, about living in the moment and about how I want to live in this particular moment.

I've discovered that all my pieces and I are one and the same. I am them and they are me: the coffee set, the Hanukkah lamp, the train, the painting, the diary and everything else – it's all me. This journey I've taken turned out to be the way to get to know myself, to discover who I am. Every single piece I've collected, everything I liked is part of me – it's like a jigsaw puzzle I had to piece together to see who I am.

The journey has taught me a great deal, it brought pain and sorrow, it taught me about love and what really matters. As an Egyptian-born Dutchman, or a Dutch Egyptian if you like, I have had the privilege of experiencing a 'missing' bit of history closer up and more personal than I ever believed I could.

These antique silver stories are a snapshot of a key part of my life. For me, all these pieces were historical monuments of Dutch and world history: *heirlooms of the past that we share.*

Ebrahim el Hadidy

www.ingramcontent.com/pod-product-compliance
Lightning Source LLC
Chambersburg PA
CBHW072246170526
45158CB00003BA/1018